Paint

IT

Written and crafted by Nicole Trollinger
Illustrated by Jeff Shelly

Paint It Contents

3 Getting Started

4 Snappy Sneakers

6 Stupendous Stepping Stones

8 Nifty Gift Boxes

10 Mood Rock Gardens

12 Ir-"resist"-ible Tropical Sarong

14 Wildlife Wastebaskets

16 Rain Forest Desk Accessories

20 Funky Flower Pot

22 Silly Switch Plates

24 Fab Photo Frames

26 Colorful Mini Furniture

28 Stylin' Sunglasses

30 Totally Unique Tote Bags and Hats

32 Follow-It Project Patterns

Getting Started

Bored with your room? Tired of plain, white sneakers? Have a cool new pic that needs a good frame? Paint It! Let your imagination run wild, beyond the canvas or paper and onto other stuff you have around you (or things you find at your local craft store). Paintings don't have to hang on a wall; in this book, you'll learn how painted objects can be stepped on, planted in, or even worn!

Go over the "Get It" list with a grownup before you start your craft, so you can get some help gathering your materials. (And you may need a grownup's help for some of the projects, just to be safe.) Some supplies can be found in your home; others are available at your local art and craft store. For most crafts, you'll be using acrylic paint, which is perfect for painting on almost any surface. Acrylic paints stain, though, so always wear old clothes when you're working, and set up a work area on a newspaper-covered table. You'll also need water, paper towels, an old pie tin (to hold and mix your paints), and small and medium paintbrushes. A good rule is to try to match the size of the job with the size of the brush (small flower = small brush, big background = bigger brush). Always rinse your brushes in clean water between colors, and wash them completely with soap and water when you're done; dry paint will ruin your brushes.

You don't need to buy all the colors in the rainbow for your Paint It projects. You can mix almost any color you want by using the color wheel (at right) to guide you. Start with the three primary colors: yellow, blue, and red. To get a secondary color (green, purple, or orange), mix the two primary colors on either side of it. To darken a color, add a touch of black; to lighten it, add the color to a little white.

Color Wheel

yellow

orange green

red blue

purple

Now be creative! Follow the designs in this book, or think of your own far-out, funky designs. But above all else, have fun painting!

Look for this symbol to let you know when a grownup's help is needed.

⚠ Watch It!
Look for this symbol to let you know when special care or precautions are needed.

Snappy Sneakers

Put your best foot forward with these fun and funky designs for your shoes!

For killer-cool shark shoes, use a sponge to apply color (and don't forget the laces!).

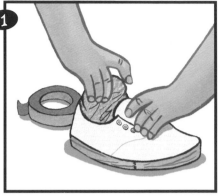

Get It!

A pair of plain, white canvas sneakers
Newspaper
Masking tape
Erasable fabric marker
Acrylic paint (bright yellow, orange,
 light blue, red, green, purple, light
 purple, and dark blue)
Paintbrushes
Water

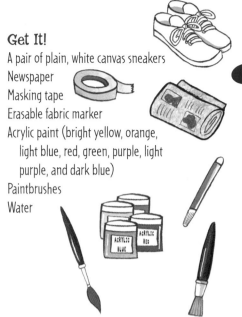

Imagine It!

If silly sharks and sunshine aren't your thing, personalize your project with a design all your own. Paint your sneakers with anything under the rainbow—after all, there's an ocean full of possibilities!

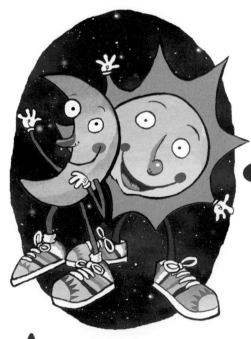

⚠ Watch It!

Take care handling the sneakers while you paint. Hold them by the rubber soles—this way the colors won't smear.

Day and Night Shoes

1

Remove the laces from your shoes, and stuff the shoes with newspaper. Cover the edges of the soles with masking tape to keep them clean and paint-free.

2

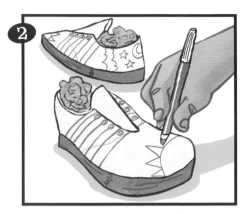

Draw on the design with a fabric marker. The sun is a half-circle with simple triangle rays, and the moon is just two curved lines. If you like, you can make each shoe design a little different.

3

Paint the center of the sun and the stars a bright yellow. Now paint all the sun's rays and one stripe of the rainbow orange. Use light blue to fill in the sky and the tongue of the shoe. Be sure to rinse out your brush each time you change colors.

4

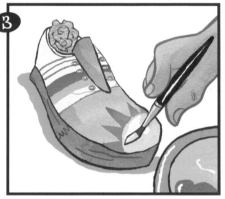

Use the same blue on the rainbow, and then add some red, green, and purple to finish. Let each color dry before you move on to the next one. Use white for the first layer of clouds next to the rainbow, and light purple for the second layer.

5

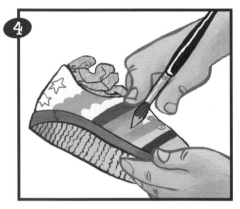

Paint the moon light purple. When it's dry, use a small brush to create the white highlight along the side. Then use a small brush to outline the stars and the moon with dark blue.

6

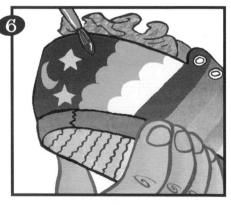

With a medium brush, fill in the rest of the sky with the same blue. Let your shoes dry completely before you put in the laces and take off the masking tape. Don't forget to wash your brushes!

Stupendous Stepping Stones

Watch your step!
These cool stepping stones
will be the center of attention
in your backyard.

For a more personal touch, step in
some paint and then onto the stone.
Decorate the edges with ants and
flowers—or whatever you want!

Get It!

Rattlesnake pattern (page 34)

Round stepping stone (can be found at the hardware store)

White acrylic gesso

Acrylic paint (purple, golden brown, bright green, teal green, orange, aqua, and pink)

Paintbrushes

Black permanent marker

Pencil

Water

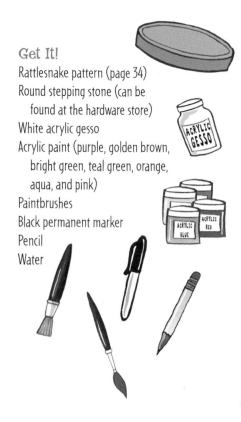

Imagine It!

The zoo, the library, and the web are all s-s-simply s-s-sensational places to find different patterns and colors for your s-s-slithery friend!

⚠ Watch It!

Remember to rinse your brushes in clean water between colors, and let each color dry before you paint the next one!

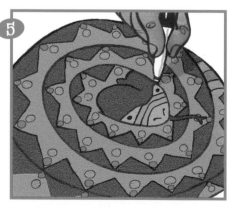

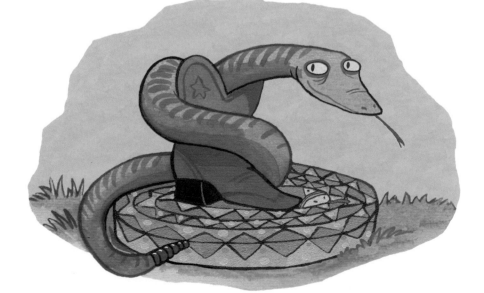

Rattlesnake Stone

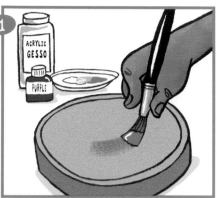

1 First prepare the stone by painting it with a medium brush and a mixture of purple paint and gesso. (The gesso will get your stone ready for painting by sealing it so the paint doesn't sink in.) Let the stone dry completely.

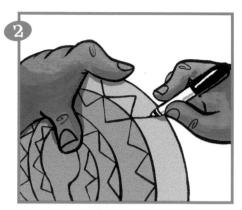

2 Follow the pattern to draw the rattlesnake in pencil, using a diamond shape for the head. Add triangles and spots to decorate the body on the top and the sides of the stone. Now trace over the drawing with your black marker.

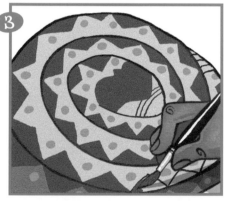

3 Paint the face and the diamond shapes golden brown, letting some of the purple gesso show through. Then use bright orange for the round spots and the stripes on the face and rattle.

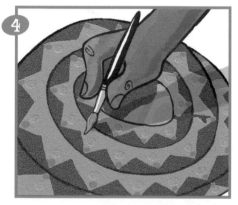

4 Paint bright green all over the rattle. Use teal green around the spots on the nose and on the rest of the face and the rattle. Then add a pink tongue and some tiny aqua dots on each diamond.

5 Once the paint is completely dry, outline everything with your black marker again, using a thicker black line around the head to make it stand out more.

Whether you make a box that's sweet or sassy, it's bound to be the perfect present for any occasion!

For this cute design, draw the face in pencil before you start painting. Glue on feathers, jewels, and glitter, and then give it as a gift to a super-special friend!

Special Stuff

Get It!

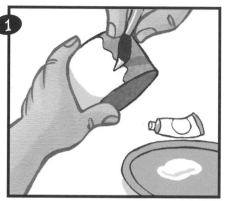

Wooden or cardboard box
Acrylic paint (white, lime green, lavender, pink, and bright yellow)
Paintbrushes
Wooden drawer knob
White craft glue
Pencil
Water

Imagine It!

What's more fun than a carousel box? One with two more inside! Paint boxes that fit into one another for a surprising gift that will stack up compliments!

⚠ Watch It!

Be careful when turning your box; you don't want to touch the wet paint and smear it!

Carousel Box

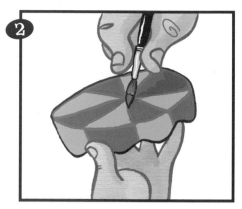

1 Paint the entire box white (to cover any imperfections). When the white layer is completely dry, draw your design on the box and the lid in pencil.

2 With a medium brush, paint in the triangles on the lid with lavender and green. When dry, use a very small brush to outline those areas in pink.

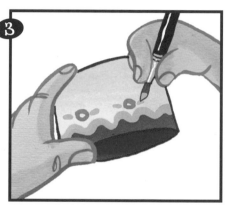

3 Paint bright yellow over the box, and then make wavy lavender and green stripes at the bottom. Add pink circles for flowers, and then add a tiny green leaf on both sides of each flower.

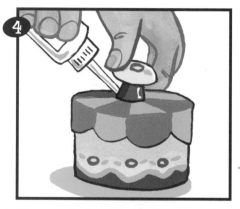

4 Paint a wooden drawer knob yellow with a pink stem. Add a flower and leaves to the top. After the knob is dry, attach it to the lid of your box with craft glue. Let it dry completely.

These gardens don't need any water or sunlight—just an occasional rearrangement to match your moods!

Paint different "mood words" on both sides of each rock, so you can always display how you're feeling!

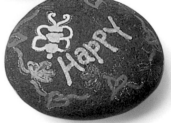

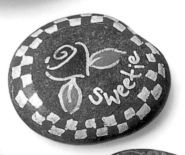

Get It!

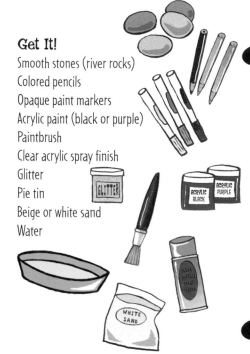

Smooth stones (river rocks)
Colored pencils
Opaque paint markers
Acrylic paint (black or purple)
Paintbrush
Clear acrylic spray finish
Glitter
Pie tin
Beige or white sand
Water

Imagine It!

Turn your rock garden into a secret code tool—leave cryptic messages in the sand or write super-secret code words on your rocks!

⚠ Watch It!

Have a grownup help with the spray finish.

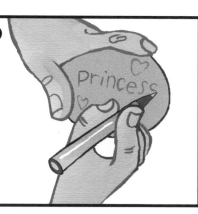

Wash the stones, and dry them completely. Then use colored pencils to draw your designs. (You can use window cleaner to erase any mistakes.)

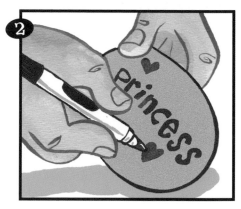

Use the paint markers to color in the words, and then add the designs around them. The paint should be dry in about 15 minutes.

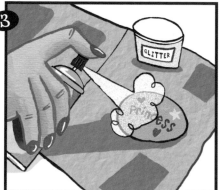

To add some sparkle, have a grownup spray the dry rocks with acrylic finish; then sprinkle on some glitter before the finish dries. Have your grownup add another coat of spray finish.

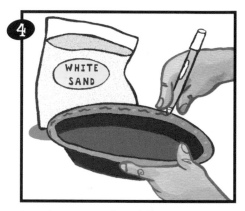

Paint the pie tin purple or black. Once it's dry, you can decorate the rim with paint markers. Then fill the tin with sand, and arrange your rocks according to how you feel that day!

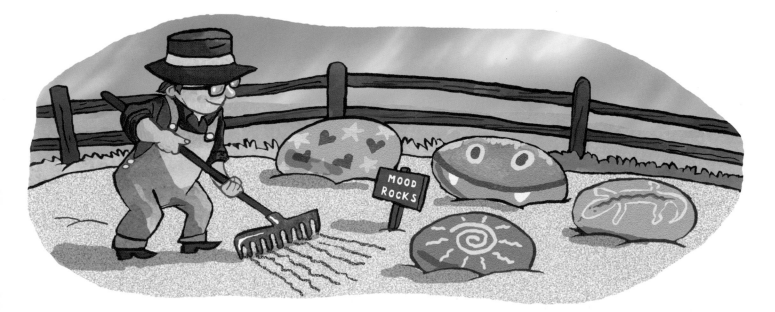

Ir-"resist"-ible Tropical Sarong

Something's fishy about this tropical coverup—the flour-and-water mixture "resists" the paint, leaving a super-cool white design!

If you have some fabric left over, try making a hair tie. (This may require a little sewing help from a grownup.)

Watch It!

- Before you start, ask a grownup to first prewash and dry your fabric and then help you cut it.
- The resist process can be messy, and the sarong needs to lie flat to dry overnight, so you may want to cover your workspace with plastic.

Get It!

100% cotton fabric piece,
about 60" x 42" (150 cm x 105 cm)

Erasable fabric marker

Fabric softener

Scissors

1/3 cup (75 ml) flour

1/2 cup (125 ml) water

Mixing bowl

Spoon or spatula

Squeeze bottle

Funnel

Acrylic paint (yellow, green, blue, pink,
orange, dark purple, and aqua)

Paintbrushes

Water

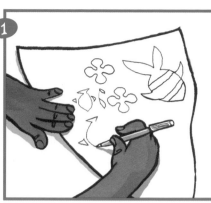

1. Wrap your fabric piece around your waist to make sure it will fit comfortably. Then have an adult help you cut the fabric into a triangle. Lay it out on a flat surface, and draw your design with the fabric marker.

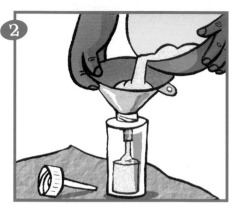

2. In a bowl, mix 1/3 cup (75 ml) of flour and 1/2 cup (125 ml) of water with a fork until it looks like pancake batter. Pour the mixture into a squeeze bottle, using a funnel. Make sure to wipe off the counter, because this mixture dries like glue!

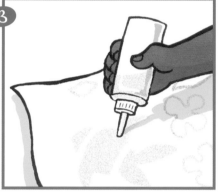

3. Draw the big fish with the squeeze bottle, filling in every shape but the stripes. Squeeze the mixture on heavily so that it soaks into the fabric. Then draw the outlines of the flowers and leaves, and make the squiggles and dots.

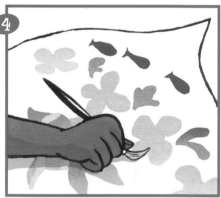

4. Let the fabric dry overnight. Then paint the designs with a medium brush, as shown, or make up your own color scheme. Let the paint dry for half an hour; then scratch off the flour and water from the fish and the water area.

5. With a heavy coat of the mixture, cover each flower, the yellow stripes on the fish, the entire water area, and the little fish. Let this coat dry overnight.

6. Once everything is dry, crumple up the fabric to break up the paint so that it's crackled. Then paint the fish and the flowers with a bright color; it will sink into the crackled paint.

7. Paint the rest of the design, and let it dry for half an hour. Rinse the fabric in the sink. Let it soak for a while in fabric softener and warm water, and then rinse it out again. Hang it out to dry.

Wildlife Wastebaskets

Transform a plain wastebasket into a wild animal refuge—with just a few strokes of the brush!

For a shiny finish to your wastebasket, ask a grownup to apply a coat of finishing spray once your painting is dry.

Get It!

Butterfly pattern (page 33)
Plastic wastebaskets
Acrylic paint (tan, dark tan, white, dark brown, black, pink, white, bright green, dark green, olive green, orange, yellow, magenta, and purple)
Paintbrushes
Pencil
Water

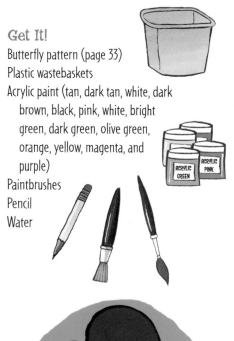

Leopard Cub Wastebasket

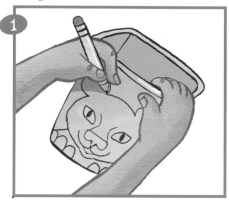

First draw a leopard design onto a wastebasket with a pencil. Then dab some tan paint over the whole face. Leopard fur is short and spotted, so try to make short, spotty brushstrokes.

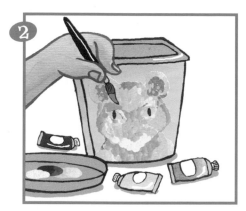

Use a darker tan for the shadows under the chin and ears. Paint the eyes, and make some white spots on the cheeks. Then add dark brown and black spots. Paint the nose pink.

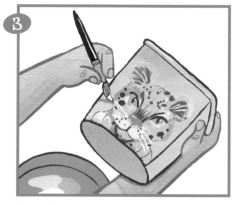

Use dark brown to outline the eyes and mouth, and dot some spots on the paws. Paint on the whiskers with a mixture of a little water and some light tan paint.

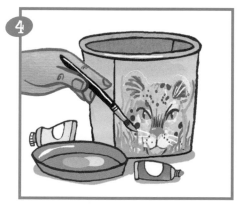

Let the leopard dry before starting on the grass. Using at least three shades of green, place your brush at the bottom and stroke up, the way the grass grows, lifting up as you finish.

Butterfly Wastebasket

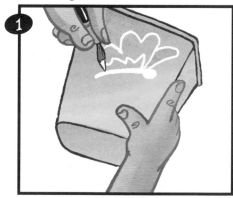

Follow the pattern to draw a butterfly on a wastebasket. Paint over the lines on the wings with white—it's okay if your lines are thick.

Fill in the wing designs as shown, or make up your own design. Cover the white as you fill in the color, leaving a thin outline around everything.

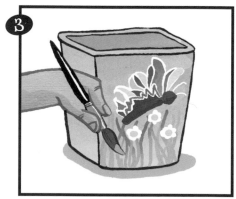

Paint the body brown with a little shading on the top edge; then add white eyes and antennae. Finally paint in the grass and flowers.

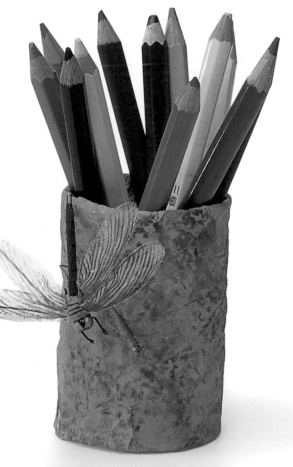

Turn your room into a rain forest retreat with these colorful desk accessories!

Get It!

Clean, empty soup can
Brown paper or paper bags
Scissors
White craft glue
Sponge
Acrylic paint (green, blue, magenta, and yellow)
Clear acrylic spray finish
Water

Rain Forest Pencil Cup

1 Make sure your soup can is clean and dry. Cut a piece of brown paper long enough to fit around the can and overlap slightly. Also make sure it's wide enough to extend beyond the top of the can.

2 Crumple up the paper until it's wrinkly and soft. Glue the paper around the can. Fold the extra paper over the edge at the top, and glue it down inside the can. Let the glue dry.

3 To create a mottled effect, paint the paper with a thin layer of light green. When it's dry, use a wet sponge to lightly dab and pat over it with a little blue, then magenta, and then yellow.

4 When the cup is dry, ask a grownup to spray it with clear acrylic spray finish. For extra flair, attach a dragonfly or butterfly to your pencil cup with craft glue or thin wire.

Get It!

Small lamp with a wooden base and a paper shade

Acrylic paint (light yellow, white, pink, bright green, light blue, dark green, and yellow)

White acrylic gesso

Paintbrushes

Pencil

Fine-point permanent black marker

Paper towels

Sponge

Water

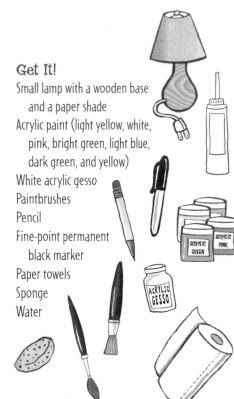

Rain Forest Lamp

With a medium brush, paint the entire base of your lamp with white gesso. When turning the lamp, be careful not to smear the wet paint with your fingers. Let the gesso dry for about 15 minutes, and then draw on your design in pencil.

Trace over the drawing with your permanent marker, and then paint the base light yellow. Be sure to paint over the black lines too; the marker will show through the paint, so don't worry about losing your design. Let the paint dry.

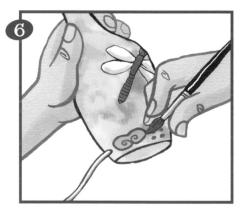

Create a pattern with bright colors that goes around the top and bottom of the lamp base. Use your paintbrush to make dots, swirls, squiggles, or whatever else you can dream up!

Imagine It!

Did you know that some rain forest species glow at night? Use glow-in-the-dark paints on your lamp to make a special "night light"!

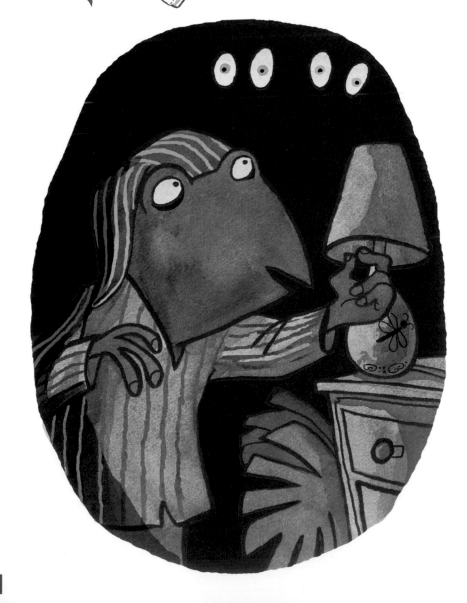

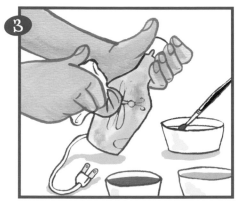

When the lamp is dry, paint it with a watery coat of white paint. While it's still wet, gently pat and wipe the lamp with a paper towel to make it look mottled. Repeat this step with pink paint and then again with green paint.

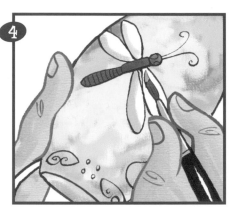

Next paint the dragonfly's body with two shades of brown, placing the dark shade on the edges and the light shade on the inside. Paint the wings white; before they dry, add a touch of light blue so the two colors blend together slightly.

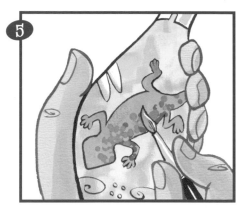

Paint the lizard bright green. Then, working in one small area at a time, make scales by dabbing first dark green and then bright green on the lizard while both colors are still wet. Add some yellow highlights, and then add eyes and a nose.

Imagine It!
Lizards and bugs are just the beginning! The rain forest is full of amazing creatures. Paint your desktop accessories with plants, birds, or anything else that tickles your fancy!

 Watch It!
Don't forget to change your rinse water when it starts looking dirty. And you'll need to rinse the sponge too, just as you would a brush.

Now paint the paper bright green to match your pencil cup. Use the same sponge technique that you used on the pencil cup, starting with blue, then sponging on magenta, and adding yellow.

Funky Flower Pot

Who says you can't play with your food? Turn green pasta and yellow rice into fancy decorations for a clay pot!

You can also paint the entire clay pot with flowery garden designs or decorate it with ribbons, jewels, fabric, or colorful paper!

Get It!

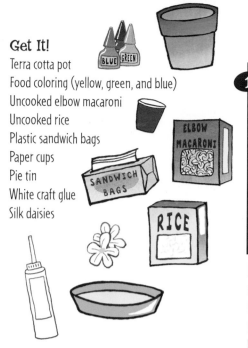

Terra cotta pot
Food coloring (yellow, green, and blue)
Uncooked elbow macaroni
Uncooked rice
Plastic sandwich bags
Paper cups
Pie tin
White craft glue
Silk daisies

Daisy Flower Pot

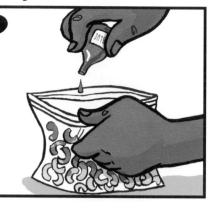

Fill a plastic sandwich bag with ½ cup (125 ml) of rice. Squeeze in a few drops of yellow food coloring, and squeeze and shake the bag until the rice is colored. Do the same to the macaroni, using blue and green food coloring.

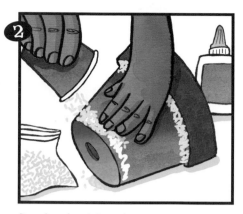

Pour the colored rice and macaroni into separate paper cups. Draw a wavy design with glue around the top rim and bottom of the pot. Then sprinkle the yellow rice on the wet glue, pressing it into the glue by hand as you go around.

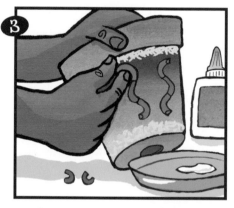

Put a little glue into a pie tin. Pick up the colored macaroni, one by one, and dip them into the glue. Make wavy daisy stems by alternating the directions of the noodles as you glue them on. Keep about 2" (5 cm) between each stem.

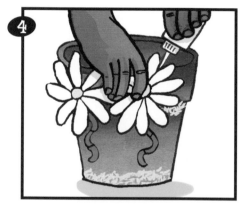

Now choose some daisies that fit onto the rim of your pot. Pull each daisy off its stem, and then cut off as much of the plastic behind the flower as possible (so it will lie flat on the rim). Glue the flowers around the rim.

Imagine It!

Plant different pasta on your pot to make kookier creations. Make waves with an ocean scene using egg noodles and shell pasta, or spell out a colorful story with alphabet pasta!

Shed some light on the situation with these fun and funky switch plates—they're a great way to brighten up any room!

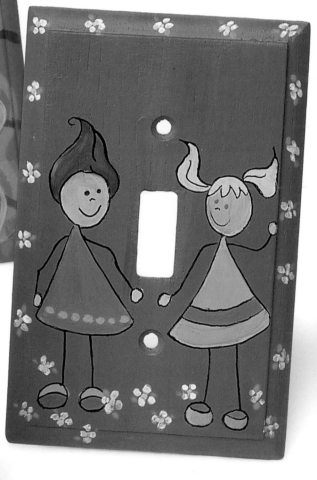

Here's a switch: Paint a plate that you can flip upside down to put a different light on the design!

Get It!

Frog switch plate pattern (page 35)
Goofy girls switch plate pattern (page 36)
Wooden switch plates
Craft foam (light green, dark green, and white)
Red fingernail polish
Scissors
Paint markers
Sandpaper
White craft glue
Paintbrush
Acrylic paints (bright green, magenta, lavender, yellow, brown, and turquoise)
Pencil
Fine-point permanent black marker
Clear acrylic spray finish
Water

⚠ Watch It!
Have a grownup help with the spray finish.

Frog Switch Plate

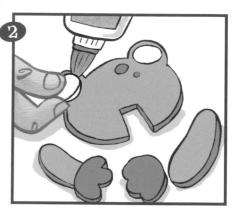

1 Trace a copy of the pattern from the back of the book onto the foam with a permanent marker. Use light green for the frog's head and legs and dark green for its feet.

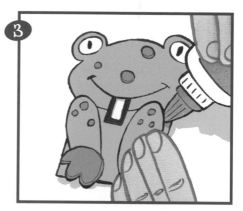

2 Cut out the frog, leaving a small black outline. For the eyes, cut out half-circles of white foam; then use a black paint marker to draw the eyeballs. Cut some warts out of the dark green foam.

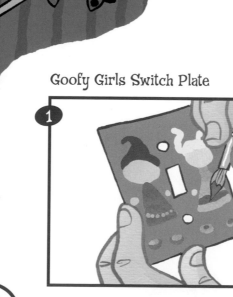

3 Paint the plate bright green, and let it dry. Then glue the frog together as shown. Use a black paint marker to draw the frog's mouth right above the switch opening. Then use red fingernail polish to turn the toggle switch into a frog's tongue.

Goofy Girls Switch Plate

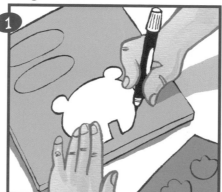

1 Paint the plate with your chosen base color. When dry, draw the girls in pencil, and outline them with a fine-point marker. Then paint them bright colors.

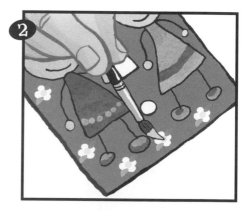

2 Paint four small white dots and a yellow center for daisies. Add green dots for the leaves. When dry, have a grownup spray it with a protective finish.

Fab Photo Frames

Good times with your fave friends are the best kinds of memories—make a collage frame to remember the fun!

This frame was decorated with paint markers and buttons, and the picture is a photocopy that was tinted with colored pencils!

joking around with friends

sweet

funny crazy good frien...

up all night long

happy giggling and...

silly laughing buddies

happy giggling

Best Friends Forever

Get It!

Wooden photo frame
Sandpaper
Acrylic paint (dark blue)
Paint markers
Feathers
Glitter
Plastic beads and jewels
White glue
Photos (for the collage)
Scrap paper
Black and colored
 construction paper
Pencil
Paintbrushes
Water

Funky Feathered Frame

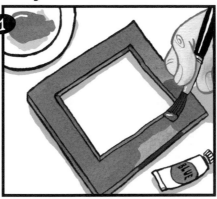

Remove the backing and the glass from the photo frame. To get the paint to stick to the frame better, scuff it a little with sandpaper. Then paint the frame with two coats of blue.

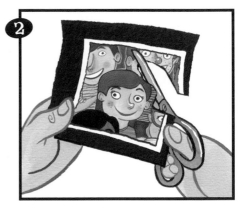

Glue each photo to one or more pieces of black paper. The photos with more paper on back will stand out more when you layer them in your collage. Then cut around the image in each photo.

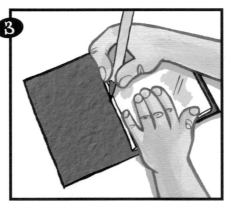

Make sure the photo you want in the background is glued to just one piece of black paper; the picture you want in front should have more pieces attached. Now use the frame's glass as a pattern to cut a colored piece of paper for the background.

Glue the background photo to the colored piece. Now make a collage by layering all the rest of your photos, gluing as you go. Save the photo you want in front for last. Then lay the frame on top of the collage to see if the edges need trimming.

Use paint markers in different colors to write words and phrases around the frame and to make dots on the flat front of the frame.

After the frame is dry, glue feathers, jewels, or beads around the sides of the frame. Work one area at a time, letting the glue dry as you go.

Colorful Mini Furniture

These mini cabinets are the perfect places to stash your jewelry, secret notes, or anything else you treasure!

This mini closet is painted to look like a tiny house—what does your dream house look like?

Get It!

Miniature wooden furniture
(found at a craft store)

Acrylic paint (white, orange,
aqua, purple, pink, green,
blue, and yellow)

Paintbrushes

Clear acrylic finish spray

Pencil

Ruler

Water

Diamond-Patterned Cabinet

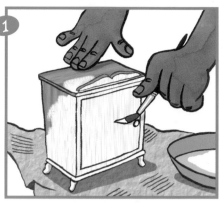

1

Before painting any unfinished wood, you should always give it a coat of white paint, or primer. (This will help your colors show up better.) Let the coat of primer dry thoroughly.

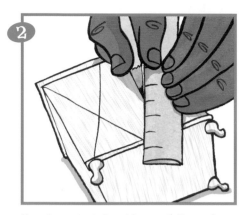

2

Next draw your design with a pencil. Use a ruler or masking tape to make straight lines from the corner to the middle of each section to make a pattern of diamonds.

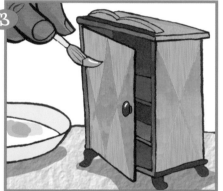

3

Now paint every other diamond orange. After the orange dries, paint the rest of the diamonds aqua. Then paint the trim and the inside purple.

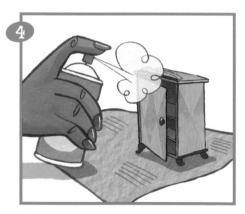

4

When everything is dry, ask a grownup to help you spray the whole piece with a clear finish to protect the paint.

⚠ **Watch It!**

Have a grownup help with the spray finish.

Take a walk on the wild side, and paint a pair of cool shades that screams out your style!

You can never have enough sunglasses! Create a pair for your Hollywood debut, your safari expedition, or wherever else your imagination takes you!

Get It!

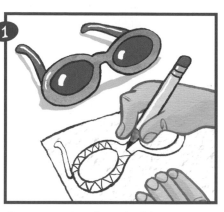

Sunglasses
Paint markers
Glitter glue
White glue
Rhinestones or plastic gems
Pencil
Scrap paper

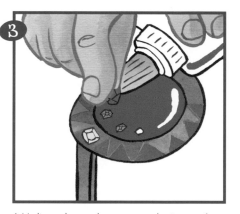

1 Choose a pair of sunglasses that have wide rims to paint on. It's always a good idea to sketch your designs on paper before you get started.

2 Start your design with the lighter colors first, and then fill in with triangles or lines of black (or another dark color).

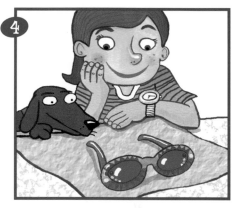

3 Add glitter glue or glue on some plastic gems for extra sparkle. You can decorate the lenses too; just make sure you keep the decoration toward the edges (so you can still see out of the glasses!).

4 Once you've decided the decorations are complete, let your sunglasses dry thoroughly before you handle them or put them on. Now enjoy those super-cool shades!

Imagine It!
Want to make your glasses really speak out? Glue on rhinestones to spell out your name or initials!

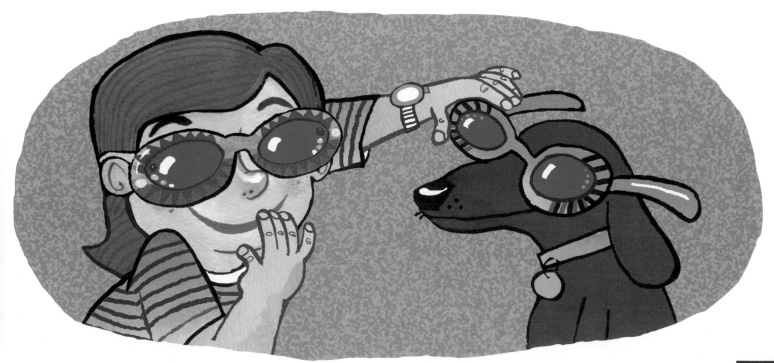

Totally Unique Tote Bags and Hats

Ever think about designing your own clothes and accessories? Deck yourself out from head to "tote"!

Create your own colorful design! Just remember to always start out with the background, and then paint in the details.

Get It!

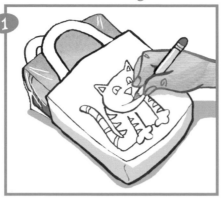

Painted pets patterns (pages 37–39)
Canvas tote and/or hat
Acrylic paint (yellow, orange, white, pink, green, brown, tan, and gray)
Small paintbrush
Paint markers
Black fabric paint
Erasable fabric marker
Newspaper
Water

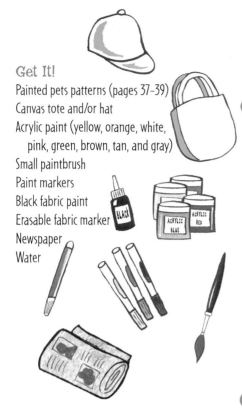

Painted Pets Tote Bag and Hat

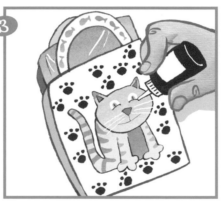

1 To keep paint from bleeding through your fabric, find a book that fits snugly inside your bag, cover it with plastic, and place it in the bag. Follow the pattern to draw the design with the fabric marker.

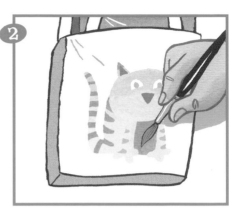

2 Paint the cat's body yellow, and let it dry. Then add orange stripes and an orange belly. Use a small brush to make the eyes white and green, and paint the nose and inside the ears pink.

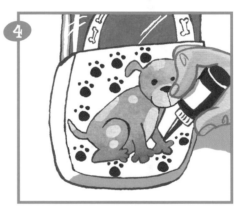

3 Once the cat is dry, use black fabric paint to outline its body and make paw prints all around it. Add orange fish to the handle of the bag, and then let everything dry.

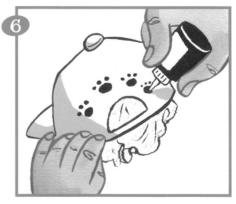

4 Now turn the bag over and paint the dog's body brown. Add some tan spots; then use black fabric paint to outline its body and add its features. Add some gray dog bones on the handle.

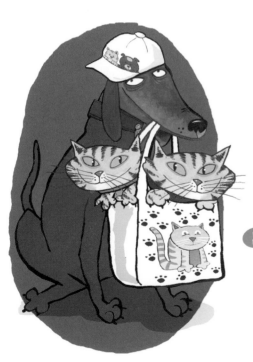

Imagine It!

Draw your own pet's portrait on your bag or hat—whether it's a hamster, rabbit, or even an iguana!

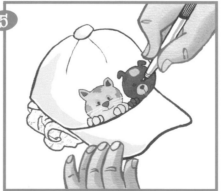

5 Now prepare the cap by stuffing it with newspaper. Draw the animals with a fabric marker, and then paint them the same way as the bag.

6 Finally, outline the animals with black fabric paint. Give the back of the cap a finishing touch by adding some paw prints around the opening.

Follow-It Project Patterns

This is where you'll find a special tear-out section of all the patterns you'll need. If you want to make a pattern bigger or smaller to customize your project, ask a grownup to help you to enlarge or reduce it on a photocopier.

Walter Foster

Walter Foster Publishing, Inc.
23062 La Cadena Drive
Laguna Hills, California 92653
www.walterfoster.com
© 2002 Walter Foster Publishing, Inc.
All rights reserved.

Special thanks to Stephanie Sarracino and the students at Bonita Canyon Elementary School
and to Robyn Allen and the students at Huntington Seacliff Elementary School for their contributions as craft consultants.

Order Code: IT02
ISBN: 1-56010-648-4
UPC: 0-50283-86402-8

Produced by the creative team at Walter Foster Publishing, Inc.:
Sydney Sprague, Associate Publisher
Pauline Foster, Art Director/Designer
Barbara Kimmel, Senior Editor
Samantha Chagollan and Jenna Winterberg, Editors
Carole Thorpe, Production Designer
Toni Gardner, Production Manager
Kathy Beeler, Production Coordinator
Monica Noemi Mijares-DeCuir, Production Artist

Printed in Korea.

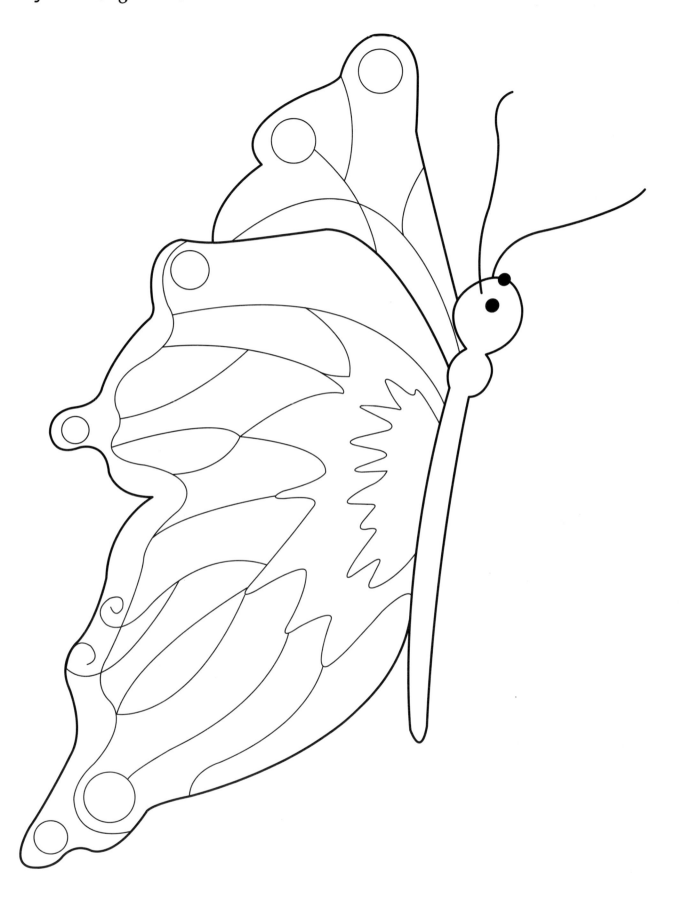

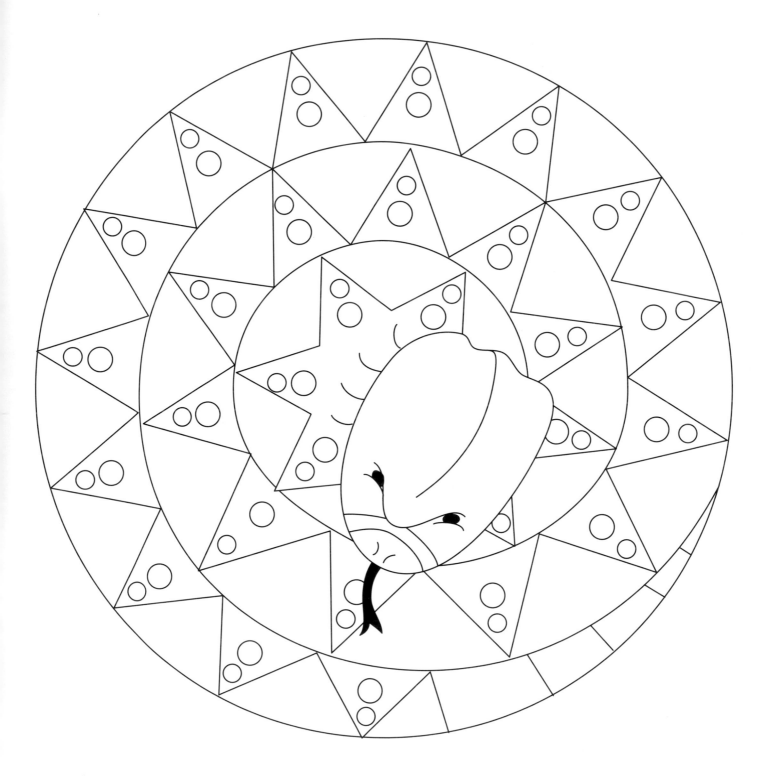

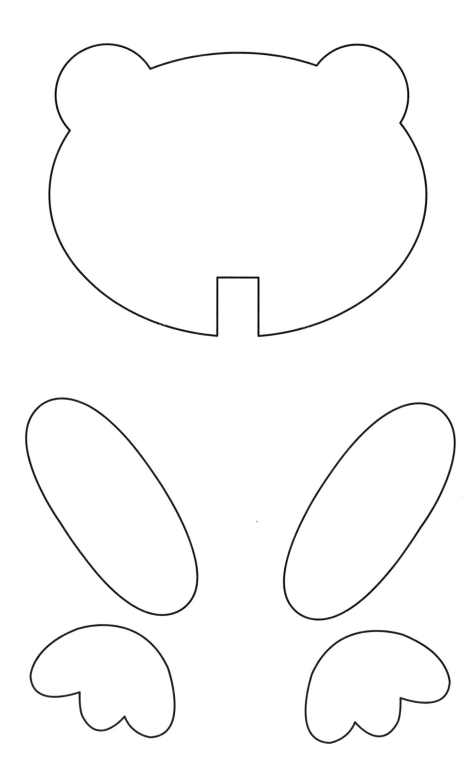

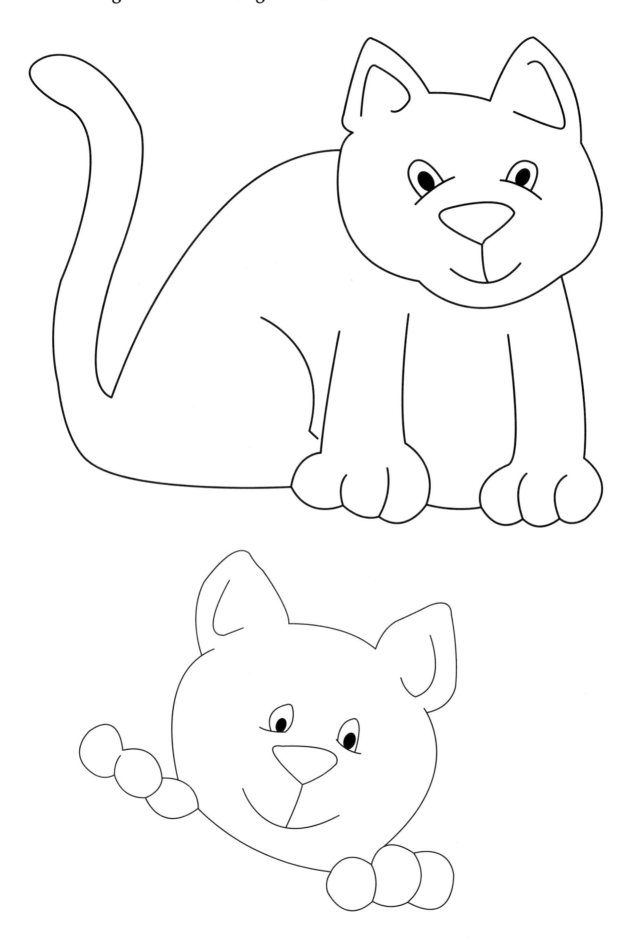